VOLUME THREE

HOW TO DRAW

FUN, FA

FELLAS

FUN FOR AGES 10-100

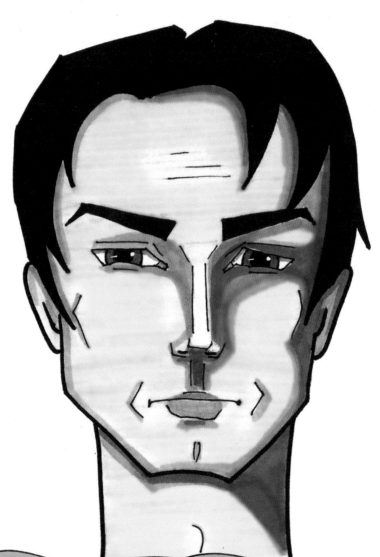

A STEP-BY-STEP GUIDE TO DRAWING AND COLORING FUN MALE FACES

KAREN CAMPBELL

About this book

I dedicate this book to all the handsome fellas in my life who continue to encourage and support all my crazy art endeavors each and every day and who have always insisted, "You need to Draw MORE men!!!". You know what? They were right! Sean, Jack, Billy and Max, this one's for you! Love you more than words or pictures could express.

Author, Illustrator, Publisher: Karen Campbell
www.karencampbellartist.com
Book Layout and Digital Design: KT Design, LLC
www.ktdesignllc.com
Editor: Tara Podvojsky

LET'S GET SOCIAL!

- awesomeartschool.com
- karencampbellartist.com
- facebook.com/karencampbellartist
- instagram.com/karencampbellartist
- etsy.com/shop/karencampbellartist
- pinterest.com/karencampbellartist
- patreon.com/karencampbellartist
- youtube.com/karencampbellartist

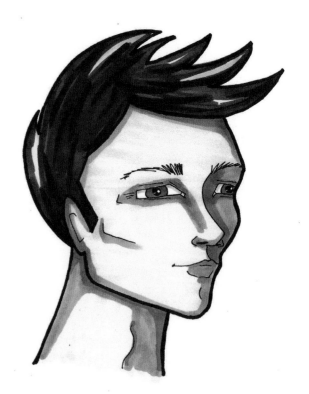

TABLE OF CONTENTS

WHAT PAGE CAN I FIND IT ON?

THE FRONT FACE: 6

FRONT SHADING GUIDE: 27

THE 3/4 VIEW: 34

3/4 SHADING GUIDE: 44

THE PROFILE: 45

PROFILE SHADING GUIDE: 52

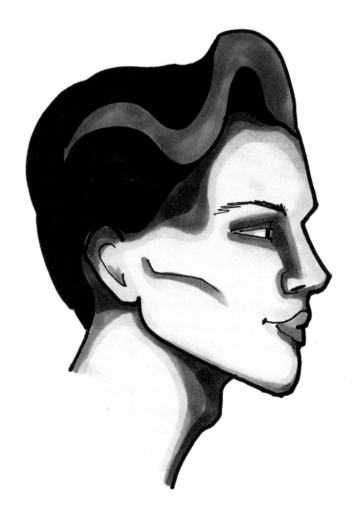

JOIN IN THE CHALLENGE, JOIN IN THE
FUN!

IN 2018 I STARTED THE #100FUNFABFACES DRAWING CHALLENGE ON YOUTUBE TO HELP MY STUDENTS WITH THEIR FACE DRAWING SKILLS. EACH WEEK FOR 20 WEEKS I GAVE A REAL-TIME DRAWING LESSON ON MY YOUTUBE CHANNEL. AFTER EACH WEEK'S LESSON, STUDENTS COULD MAKE UP TO 5 VARIATIONS OF THE LESSON. FUN VARIATIONS INCLUDED CHANGING UP THE HAIR STYLE OR TRYING OUT NEW COLORS. AFTER 20 WEEKS, THE GOAL IS TO HAVE CREATED 100 FACES! I'VE SEEN THE PROGRESS STUDENTS HAVE MADE FOLLOWING THE CHALLENGE AND THE RESULTS ARE INCREDIBLE!!!

THE BEST PART IS THAT ALL THE LESSONS ARE COMPLETELY FREE AND, FOR YOUR CONVENIENCE, I'VE SINCE COLLECTED ALL THE LESSONS, ADDED RESOURCES LIKE REFERENCE PDFS, LINKS TO SUPPLIES, ETC. AND PUT THEM ONTO MY WEBSITE INTO A FREE CLASSROOM. IF YOU DECIDE TO JOIN US IN THE CHALLENGE, BE SURE TO USE THE HASHTAG #100FUNFABFACES ON SOCIAL MEDIA SO WE CAN FIND YOUR DRAWINGS TOO!

Here's the link to join: bit.ly/100funfabfaces

WELCOME

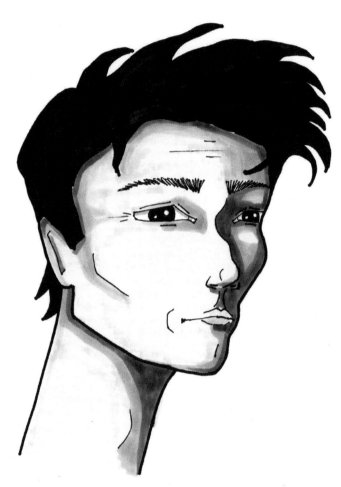

I AM VERY HAPPY TO BRING YOU THIS LONG AWAITED BOOK ON DRAWING...DUDES!

THANK YOU FOR BEING HERE! AS MANY OF YOU KNOW, DRAWING FUN, FABULOUS FEMALE CHARACTERS IS MY ALL-TIME FAVORITE PASTTIME. BUT LET'S NOT FORGET THE OTHER 50% OF THE HUMAN POPULATION!

IN THIS BOOK, WE WILL COVER ALL THE BASICS. I'LL SHOW YOU HOW TO DRAW DUDES OF ALL KINDS IN FORWARD FACING, PROFILES, 3/4 VIEW AS WELL AS HOW TO COLOR OUR FAB GUYS USING SIMPLE SHADING TECHNIQUES.

THANKS AGAIN FOR JOINING ME ON ANOTHER AMAZING DRAWING ADVENTURE AS WE LEARN HOW TO DRAW FUN, FAB FELLAS!

THE FRONT FACE

THE METHODS FOR DRAWING MALE FACES ARE THE SAME ONES I USE FOR DRAWING FEMALE FACES. WHAT DIFFERS ARE THE FEATURES THEMSELVES. NOW LET'S BEGIN!

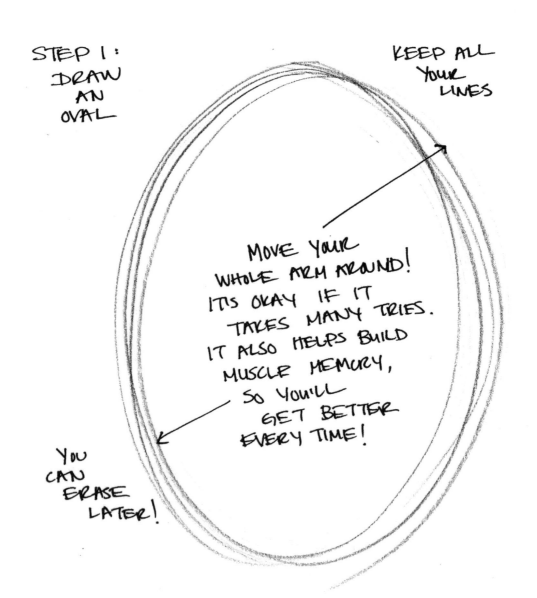

STEP 1:
DRAW
AN
OVAL

KEEP ALL
YOUR
LINES

MOVE YOUR
WHOLE ARM AROUND!
IT'S OKAY IF IT
TAKES MANY TRIES.
IT ALSO HELPS BUILD
MUSCLE MEMORY,
SO YOU'LL
GET BETTER
EVERY TIME!

YOU
CAN
ERASE
LATER!

NEXT, DIVIDE YOUR OVAL DOWN THE MIDDLE AND ACROSS THE MIDDLE, LIKE THIS!

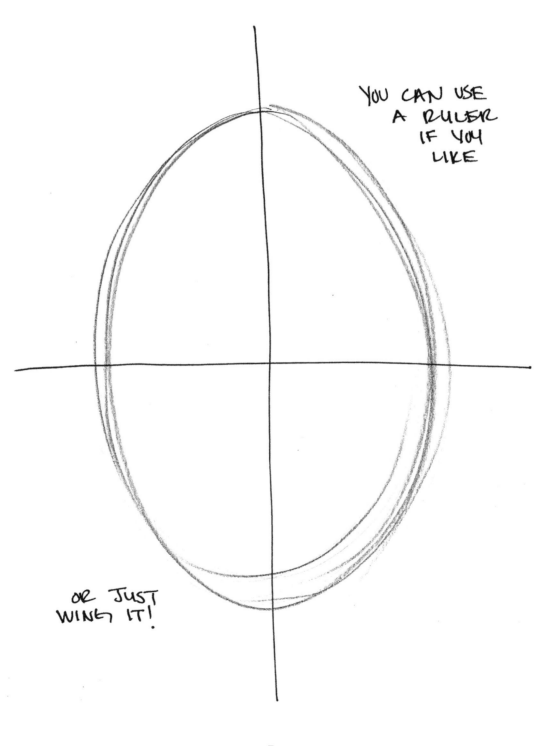

YOU CAN USE
A RULER
IF YOU
LIKE

OR JUST
WING IT!

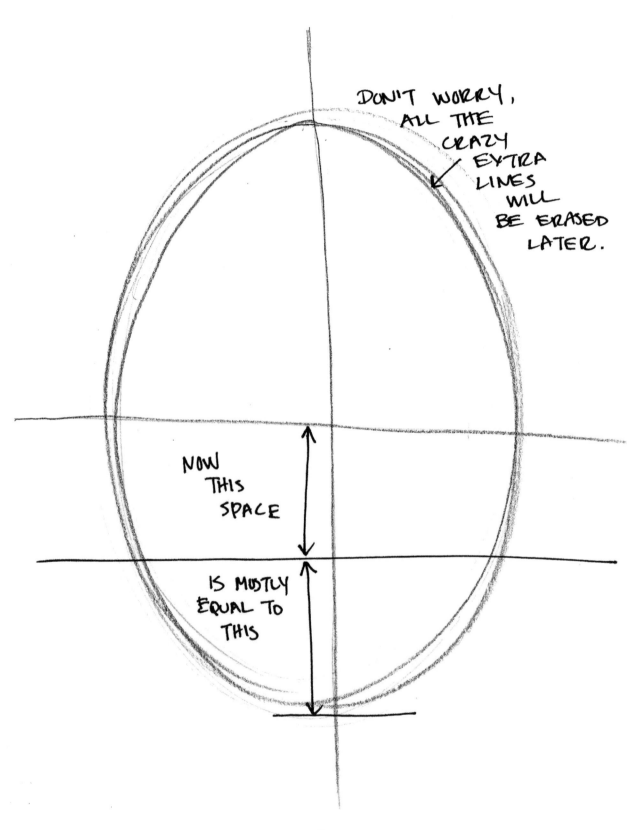

DON'T WORRY, ALL THE CRAZY EXTRA LINES WILL BE ERASED LATER.

NOW THIS SPACE

IS MOSTLY EQUAL TO THIS

AND NOW FOR OUR LAST GUIDELINE, WE NEED TO DIVIDE THAT LAST NEW SPACE IN HALF AGAIN (AND THEN WE'RE DONE, I PROMISE!).

AGAIN, THESE SHOULD BE ABOUT THE SAME!

HERE IS THE POINT WHERE THE MEN'S FACE MAP DIFFERS FROM THOSE OF THEIR FAB, FEMALE COUNTER PARTS. BEFORE WE DO ANYTHING ELSE WE GOTTA GIVE THIS DUDE A CHIN HE CAN BE PROUD OF! AND A GOOD SOLID NECK TO GO BEHIND IT TOO.

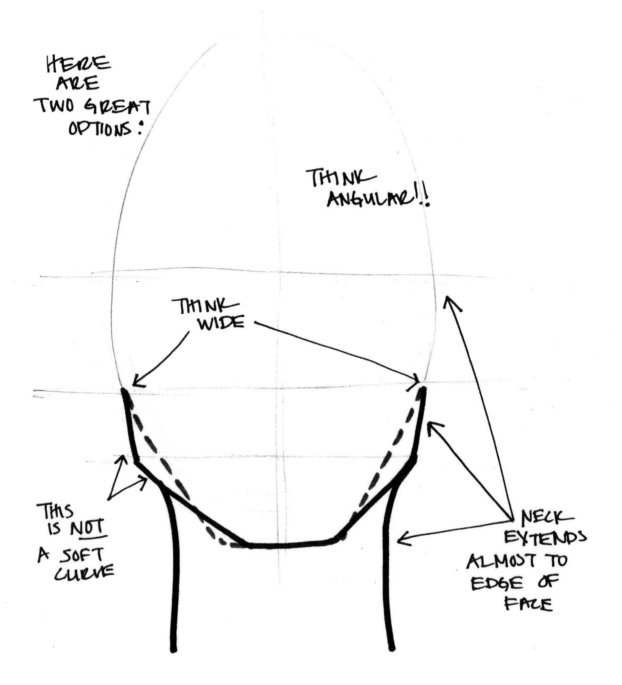

HERE ARE TWO GREAT OPTIONS:

THINK ANGULAR!!

THINK WIDE

THIS IS NOT A SOFT CURVE

NECK EXTENDS ALMOST TO EDGE OF FACE

NOW THAT WE HAVE THAT MANLY NECK AND CHIN FIGURED OUT, LET'S POP IN THE PLACEHOLDERS FOR THE REST OF HIS FEATURES.

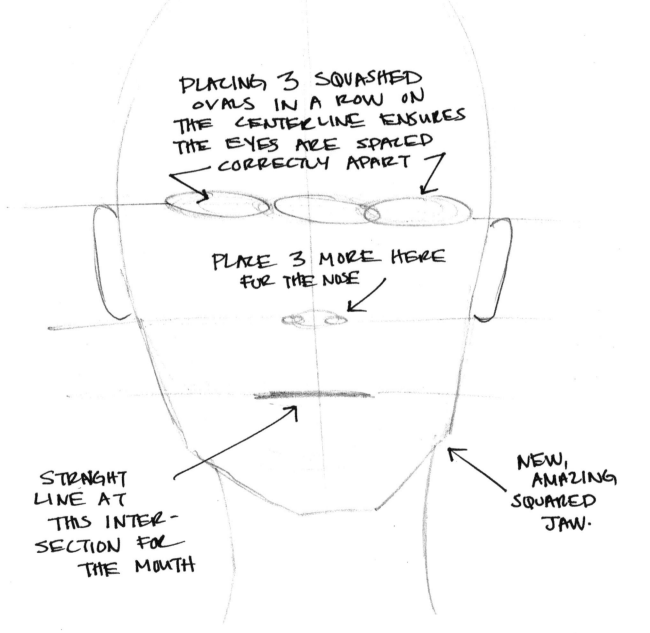

PLACING 3 SQUASHED OVALS IN A ROW ON THE CENTERLINE ENSURES THE EYES ARE SPACED CORRECTLY APART

PLACE 3 MORE HERE FOR THE NOSE

STRAIGHT LINE AT THIS INTER- SECTION FOR THE MOUTH

NEW, AMAZING SQUARED JAW.

NOW THAT WE KNOW WHERE EVERYTHING IS SUPPOSED TO GO, LET'S TALK PARTICULARS. WITH FEMALE FACES, THE EYES ARE ACCENTUATED. THEY ARE OFTEN DRAWN LARGER AND ARE FILLED WITH SPARKLES AND COLORED MAKEUP AND TOPPED WITH DRAMATIC LASHES. FOR DUDES THOUGH?? YEAH...NO. THINK SMALL, ANGULAR, SQUINTY, LASHLESS, TOUGH. LESS AWESOME? NO. LESS GIRLY? WELL, THAT'S THE IDEA!

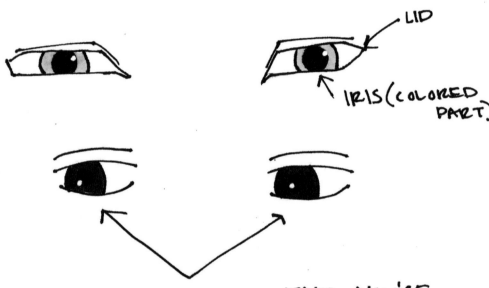

NO MATTER WHOSE EYE YOU'RE DRAWING, ALWAYS MAKE SURE THOSE IRISES ARE CROPPED BY THE LIDS.

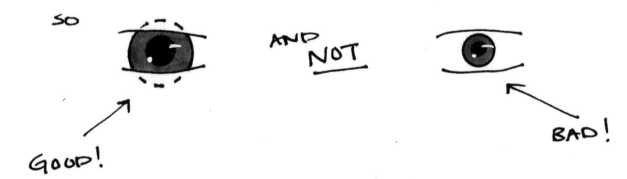

MAKE SURE TO KEEP YOUR LINES ANGULAR. SKIP THE LASHES ALTOGETHER, AND KEEP THE LID SMALL.

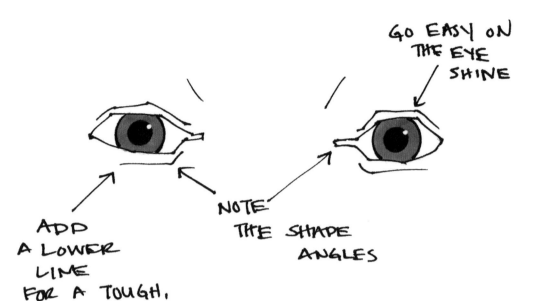

GO EASY ON THE EYE SHINE

ADD A LOWER LINE FOR A TOUGH, WORN LOOK

NOTE THE SHADE ANGLES

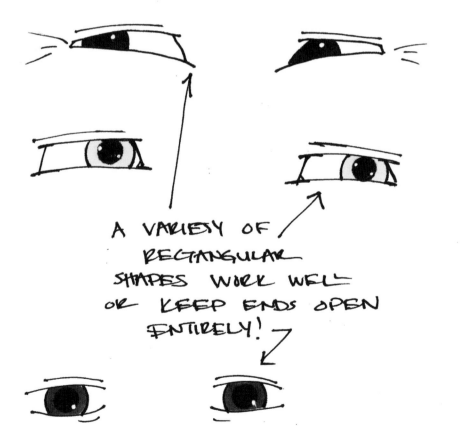

A VARIETY OF RECTANGULAR SHAPES WORK WELL OR KEEP ENDS OPEN ENTIRELY!

OF COURSE I THINK EVERYONE KNOWS HOW MUCH EYEBROWS CONTRIBUTE
TO A CHARACTERS, WELL, CHARACTER! MEN'S EYEBROWS ARE A BLAST TO
DRAW BECAUSE THEY ARE SUBSTANTIAL! AND HAIRY! AND FUN!
HERE ARE SOME IDEAS TO GET YOUR STARTED.

THE MALE DIVA

ALWAYS WITH
THE HIGH ARCH

THE
CATERPILLARS

THE SCULPTED

THE BARELY THERE

THE EXPRESSIVE

NOSES CAN HAVE A LOT MORE PERSONALITY, OR VARIETY WHEN DRAWING DUDES AS WELL. I ALSO ALWAYS TEND TO DRAW THE ACTUAL NOSE BRIDGE ON A DUDE WHERE I ONLY EVER DRAW THE TINY END OF THE NOSE WHEN I AM DRAWING FEMALES. SO HEY! LET'S HAVE SOME FUN WITH THIS THEN!

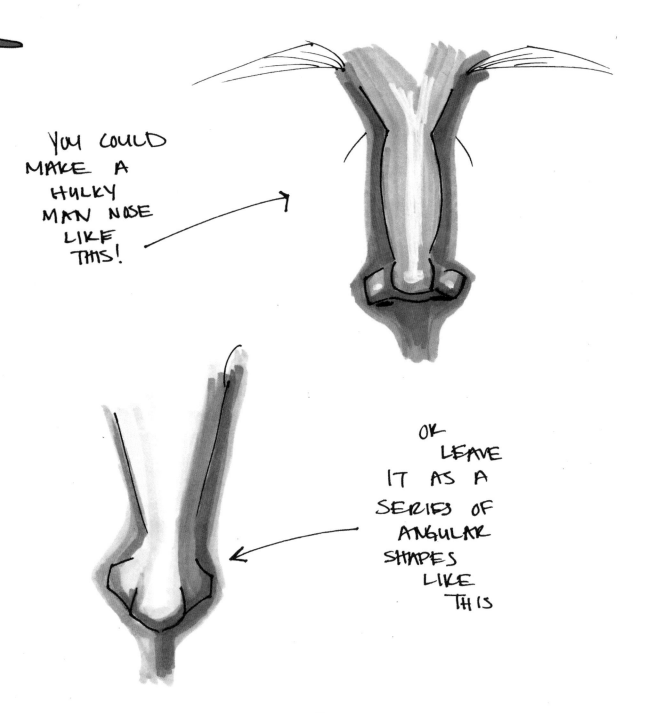

YOU COULD MAKE A HULKY MAN NOSE LIKE THIS!

OK LEAVE IT AS A SERIES OF ANGULAR SHAPES LIKE THIS

YOU DON'T HAVE TO DRAW A NOSE WITH A BRIDGE SHOWN.

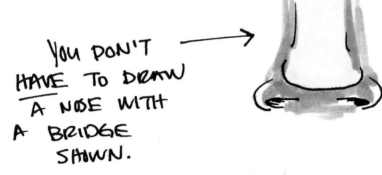

SOMETIMES LESS IS MORE

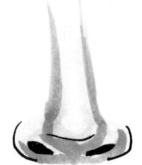

SOMETIMES JUST A QUICK AND SIMPLE GESTURE WILL SUFFICE!

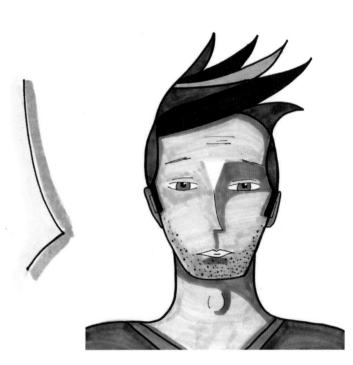

AND THEN LET SHADING DO THE REST!

YOU NEED TO BE CAREFUL WHEN DRAWING THE MOUTHS OF DUDES. IT IS VERY EASY FOR YOUR "HE" TO BECOME A "SHE" JUST BY HAVING THE MOUTH ALONE NOT QUITE RIGHT. HERE ARE SOME EASY TIPS TO PREVENT THAT FROM HAPPENING.

TIP 1: EVEN IF A MAN HAS A FULL UPPER LIP, NEVER DRAW ONE. INSTEAD, STRETCH AND FLATTEN IT OUT.

YOU THEN HAVE A GREEN LIGHT TO PROCEED WITH A FULL BOTTOM LIP. IF YOU MUST.

BUT ALWAYS PAIR THAT WITH A DEFINITE, SOLID LINE IN THE CENTER, LIKE THIS.

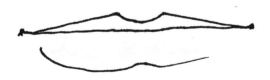

TIP 2: SKIP THE UPPER LIP ENTIRELY.
SOUNDS WEIRD, LOOKS RIGHT.

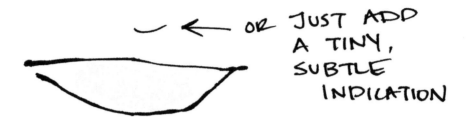

OR JUST ADD A TINY, SUBTLE INDICATION

TIP 3: ALWAYS DEPICT A GOOD, HEAVY SHADOW UNDER THE LOWER LIP.
AND ADD A SOLID CHIN LINE TOO.

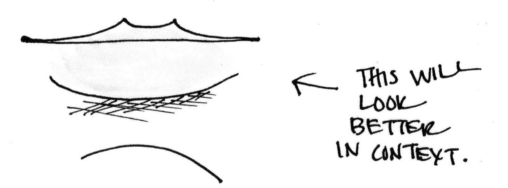

THIS WILL LOOK BETTER IN CONTEXT.

TIP 4: ADD FACIAL HAIR.
WE WILL DRAW MORE ON THIS IN JUST A FEW PAGES!

I NEVER GO CRAZY WITH THE EARS. BUT LIKE ALL THINGS DUDE RELATED, YOU CAN DEFINITELY OPT TO MAKE SOME WELL DEFINED, ANGULAR ONES IF YOU LIKE!

FROM THE FRONT YOU'D SEE:

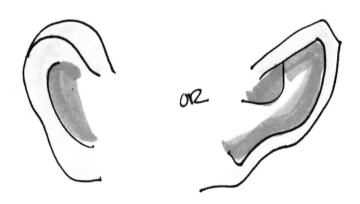

FROM THE SIDE YOU CAN SEE MORE:

I THINK SIMPLE IS BETTER, BUT THAT'S JUST ME!

OK, SO NOW THAT WE'VE GONE OVER ALL THE FEATURES, LET'S PUT IT ALL
TOGETHER, AND THEN WE'LL TALK HAIR AND SHADING!
I'LL KEEP THE GUIDELINES SHOWN SO YOU CAN SEE HOW IT
ALL COMES TOGETHER.

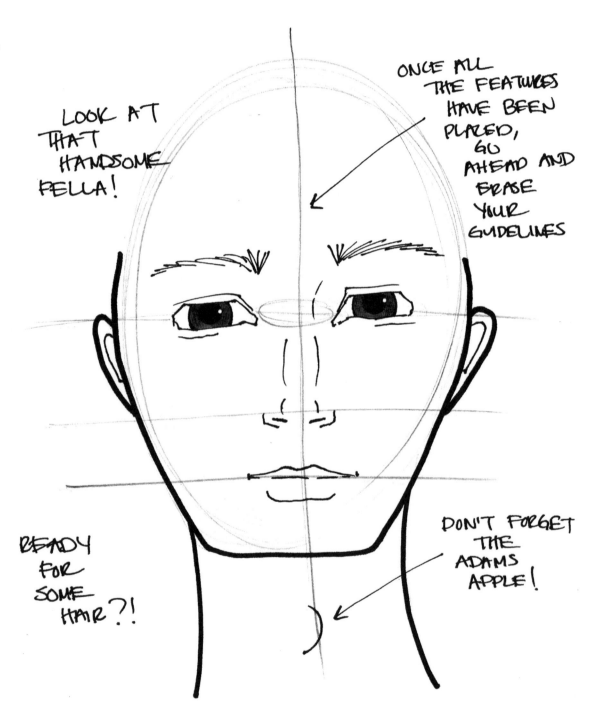

IF YOU'VE TAKEN ANY OF MY CLASSES, OR READ MY BOOKS ON DRAWING FEMALE FACES, YOU KNOW THAT WE ALWAYS START BY IDENTIFYING WHERE THE PART IS ON THE HEAD. THEN WE MAKE SURE HAIR GOES UP AND OVER THE HEAD CIRCLE, AS WELL AS OVER THE FOREHEAD OR SOMEHOW ACROSS THE FACE.

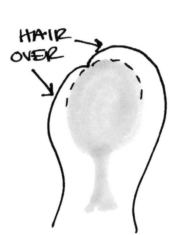
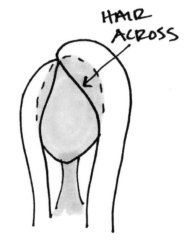

PART

HAIR OVER

HAIR ACROSS

SO WHEN DRAWING FUN, FAB, FELLAS, THE SAME IS TRUE ABOUT STEPS 2 AND 3, BUT A LOT OF TIMES YOU CAN SKIP THE PART, PART.

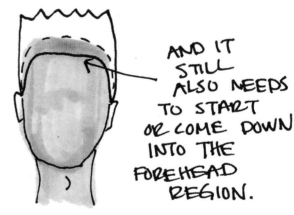

HAIR STILL NEEDS TO GO UP AND OVER HEAD CIRLLE

AND IT STILL ALSO NEEDS TO START OR COME DOWN INTO THE FOREHEAD REGION.

WHAT ARE SOME COOL DUDE'S HAIRSTYLES?
WELL, LET'S COME UP WITH SOME!

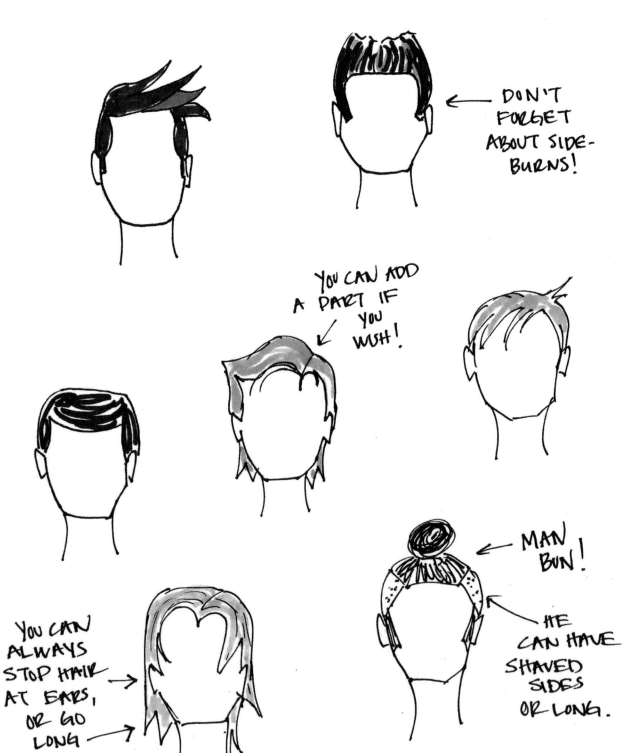

THERE ARE WAY MORE POSSIBILITIES FOR MAN HAIR THAN FEMALE WHEN YOU COME RIGHT DOWN TO IT. AND DON'T FORGET, MEN HAVE FACIAL HAIR TOO!!!

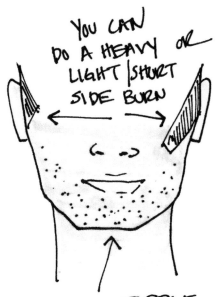

YOU CAN DO A HEAVY OR LIGHT/SHORT SIDE BURN

SHOW STUBBLE WITH POLKA-DOTS. VARY SIZES IF YOU CAN!

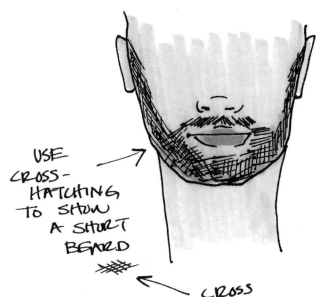

USE CROSS-HATCHING TO SHOW A SHORT BEARD

CROSS HATCHING IS SIMPLY SHORT, QUICK LINES GOING IN OPPOSITE DIRECTIONS.

OR USE A COMBO OF COLOR AND PEN.

MAN OH MAN THE POSSIBILITIES ARE ENDLESS!

RECOGNIZE THIS HANDSOME GUY? HE'S THE PERFECT SPECIMEN...ER...
EXAMPLE OF ALL THE FUN EXTRAS YOU CAN ADD TO A MALE FACE THAT
YOU DEFINITELY WOULDN'T WANT ON A FEMALE.

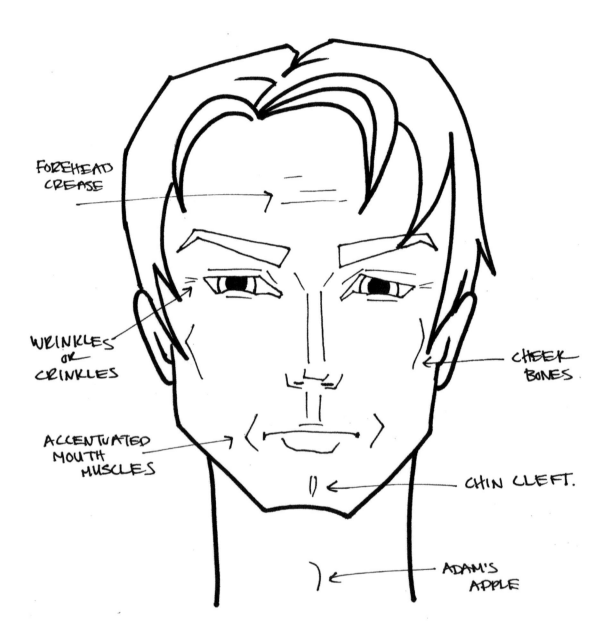

FOREHEAD
CREASE

WRINKLES
or
CRINKLES

ACCENTUATED
MOUTH
MUSCLES

CHEEK
BONES

CHIN CLEFT.

ADAM'S
APPLE

SEE HOW THE ANGULAR LINES REALLY BRING OUT HIS MASCULINITY?
NO SOFT CURVES HERE!

WANT TO LEARN HOW TO TAKE YOUR HANDSOME GUY TO THE NEXT LEVEL?
THEN YOU'VE COME TO THE RIGHT PLACE!
LET'S TALK COLORS AND SHADING.

FOR MY COLORING TECHNIQUES IN THIS BOOK I USE A COMBINATION OF
VARIOUS ALCOHOL BASED MARKERS. USE WHATEVER TOOLS YOU HAVE LYING
AROUND, IT'S ALL GOOD - AND THESE LAYERING TECHNIQUES CAN BE EASILY
USED WITH COLORED PENCILS, WATER SOLUBLE MEDIA AND PAINT!

THE CONCEPT IS SIMPLE. YOU HAVE A LIGHT SOURCE, AND IT CASTS LIGHT
UPON AN OBJECT. NO MATTER WHAT THE OBJECT, THE PLACES CLOSEST TO
THE LIGHT ARE RENDERED THE LIGHTEST, AND THE NOOKS, CRANNIES AND
PLANES FARTHEST WILL BE THE DARKEST! NOW LET'S BEGIN!

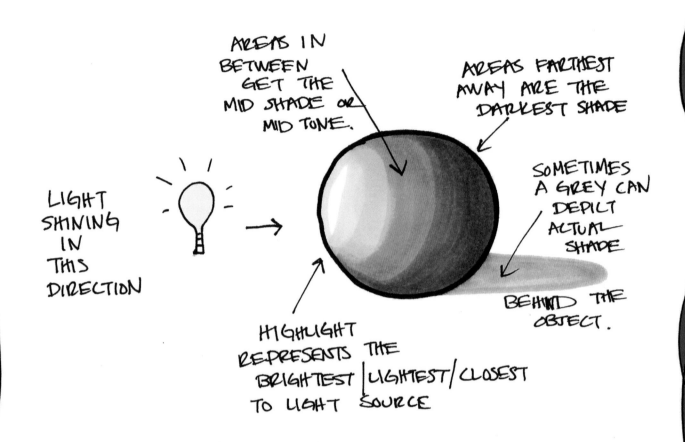

AREAS IN BETWEEN GET THE MID SHADE OR MID TONE.

AREAS FARTHEST AWAY ARE THE DARKEST SHADE

SOMETIMES A GREY CAN DEPICT ACTUAL SHADE

LIGHT SHINING IN THIS DIRECTION

BEHIND THE OBJECT.

HIGHLIGHT REPRESENTS THE BRIGHTEST / LIGHTEST / CLOSEST TO LIGHT SOURCE

THE SAME THING HAPPENS WHEN WE COLOR FACES. IF YOU'RE UNSURE WHERE TO DEPICT THOSE LAST SHADOWS, LOOK UP BLACK AND WHITE PORTRAIT PHOTOS ONLINE OR USE THE CHART ON THE NEXT PAGE AND THE SHADOWS WILL REALLY POP!

SO LET'S PICK OUR 3 SHADES AND GET SHADING!

FRONT SHADING GUIDE

USE THIS HELPFUL GUIDE TO HELP YOU DETERMINE WHERE YOUR SHADING GOES BASED ON THE DIRECTION OF YOUR LIGHT SOURCE!

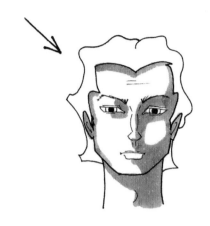 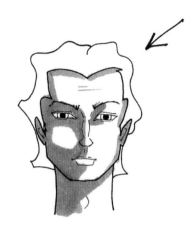

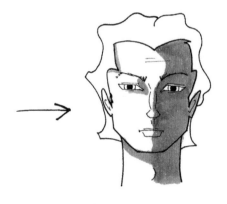 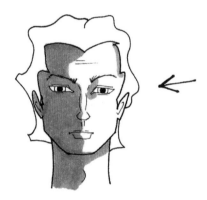

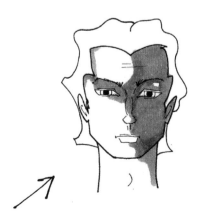 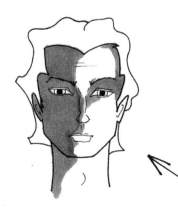

DO WHATEVER 3 SHADES WORK BEST FOR YOUR CHARACTER. AS YOU KNOW, HUMANS COME IN A BEAUTIFUL ARRAY OF SKIN COLORS SO CHOOSE WHICHEVER WORKS FOR YOU! HERE ARE SOME EXAMPLES OF SKIN TONES USING 3 OF MY FAVORITE ALCOHOL MARKER BRANDS: COPICS, SPECTRUM NOIR AND PRISMACOLOR.

COPIC CIAO E000

COPIC CIAO E00

COPIC CIAO E11

SPECTRUM NOIR "CREAM" FS6

COPIC SKETCH "SAND" E33

COPIC SKETH "HAZELNUT" E23

PRISMA-COLOR "SAND" PM-70

COPIC SKETCH "HAZELNUT" E23

SPECTRUM NOIR TN7

COLORED PENCILS, CRAYONS AND PAINTS ARE (OBVIOUSLY) EQUALLY FAB!

SO LET'S DO A PROJECT FROM BEGINNING TO END AND PUT
ALL THE PIECES TOGETHER.

START WITH YOUR SKETCH. HERE IS MINE. I LEFT ALL THE GUIDELINES IN
PLACE SO YOU CAN CLEARLY SEE I PRACTICE WHAT I PREACH!

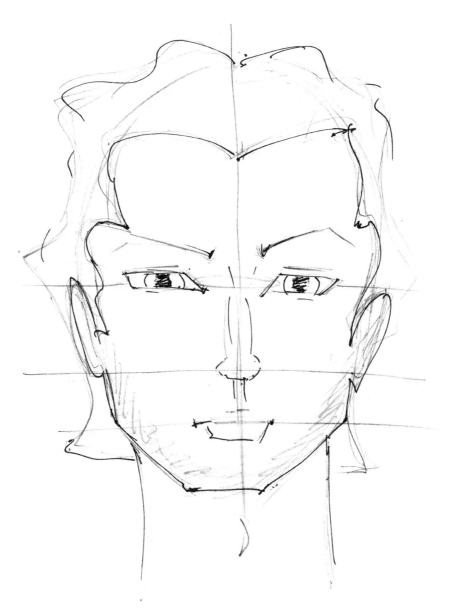

DO A FEW VERSIONS UNTIL YOU FIND THE GUY THAT'S RIGHT FOR YOU!

MY NEXT STEP IS THEN TO TRACE OVER MY SKETCHY LINES WITH SHARPIE.

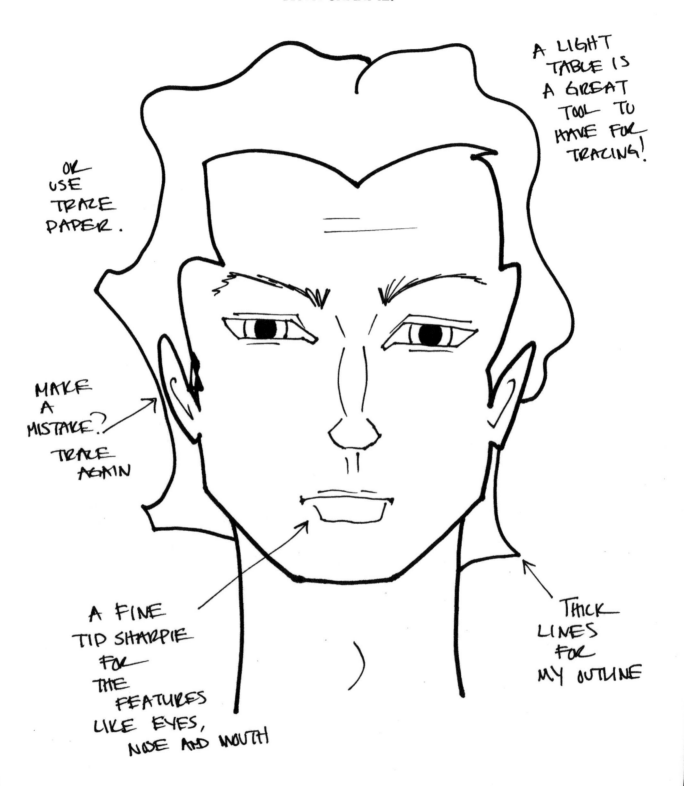

A LIGHT TABLE IS A GREAT TOOL TO HAVE FOR TRACING!

OR USE TRACE PAPER.

MAKE A MISTAKE? TRACE AGAIN

A FINE TIP SHARPIE FOR THE FEATURES LIKE EYES, NOSE AND MOUTH

THICK LINES FOR MY OUTLINE

THERE ARE MANY WAYS TO SHADE A FACE, MOSTLY BECAUSE THE SHADE WILL VARY, DEPENDING ON WHERE YOUR LIGHT SOURCE IS COMING FROM AS WE DISCUSSED. I'M GOING TO SHOW YOU MY FAVORITE METHOD.

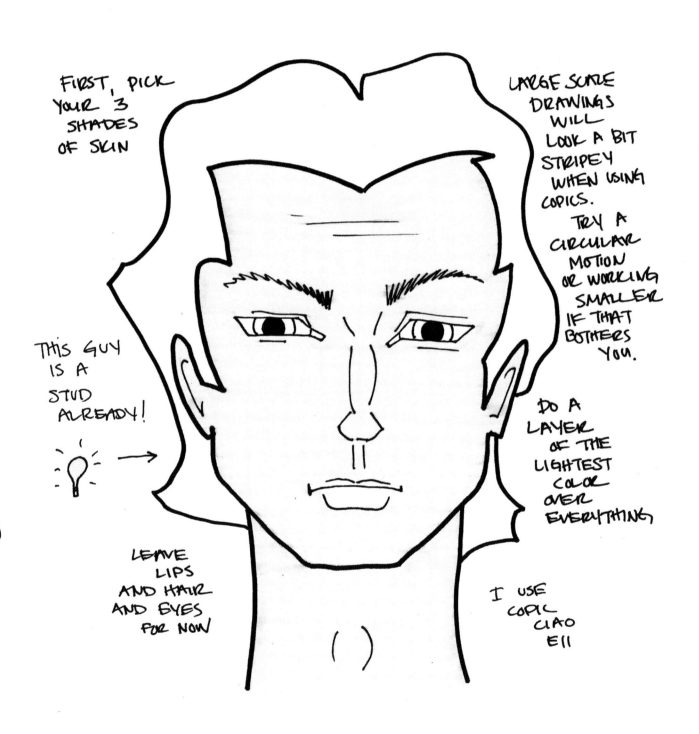

FIRST, PICK YOUR 3 SHADES OF SKIN

LARGE SCALE DRAWINGS WILL LOOK A BIT STRIPEY WHEN USING COPICS. TRY A CIRCULAR MOTION OR WORKING SMALLER IF THAT BOTHERS YOU.

THIS GUY IS A STUD ALREADY!

DO A LAYER OF THE LIGHTEST COLOR OVER EVERYTHING

LEAVE LIPS AND HAIR AND EYES FOR NOW

I USE COPIC CIAO E11

NOW GET OUT YOUR SECOND DARKEST COLOR. IF THIS LOOK IS TOO DRAMATIC FOR YOU, SIMPLY CHOOSE A COLOR THAT IS NOT QUITE AS DARK.

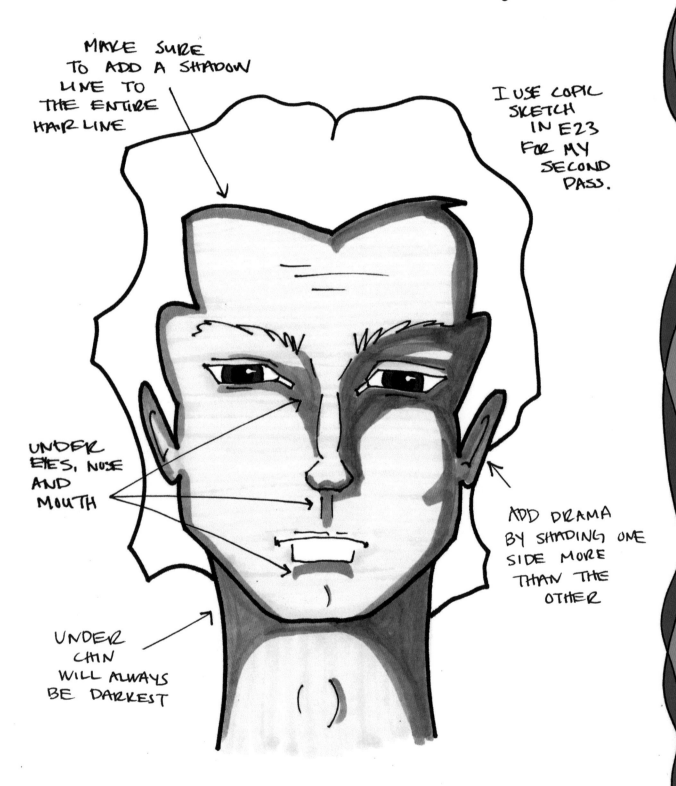

MAKE SURE TO ADD A SHADOW LINE TO THE ENTIRE HAIR LINE

I USE COPIC SKETCH IN E23 FOR MY SECOND PASS.

UNDER EYES, NOSE AND MOUTH

ADD DRAMA BY SHADING ONE SIDE MORE THAN THE OTHER

UNDER CHIN WILL ALWAYS BE DARKEST

NOW, WITH YOUR DARKEST DARK, GO OVER THOSE SHADED AREAS ONE FINAL TIME. BE CAREFUL TO LEAVE THE PREVIOUS AREA STILL SHOWING. THE RESULT IS A DRAMATIC GRADIENT!

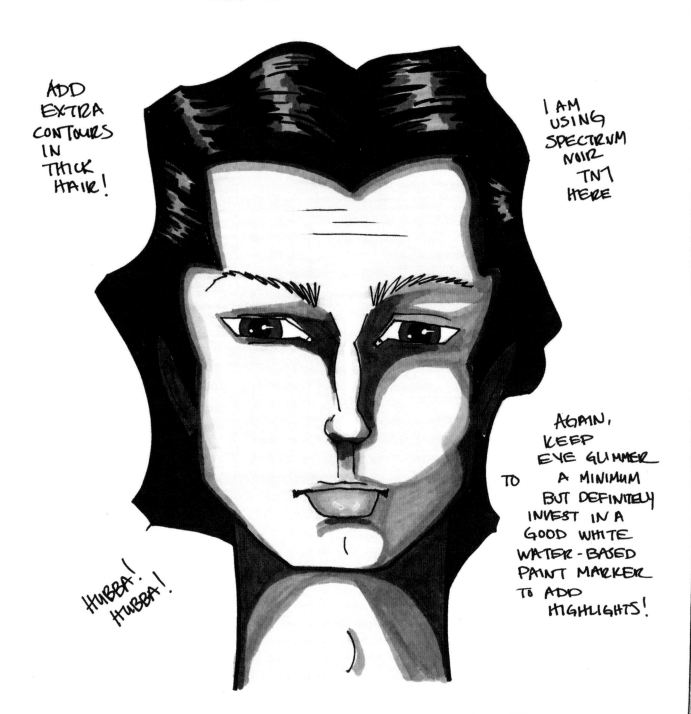

AND DON'T FORGET TO HAVE FUN WITH THE REST!

THE 3/4 VIEW

NOW THAT WE HAVE MASTERED THE FRONT FACING MALE FACE, LET'S TRY A DIFFERENT ANGLE! A POPULAR MODELING POSTURE (AS WELL AS DRAWING APPROACH) IS THE "3/4 PORTRAIT". THE HEAD IS TURNED A QUARTER OF THE WAY TO THE SIDE AND THE RESULT IS THAT YOU ARE LOOKING AT 3/4 OF THE FACE. SHALL WE BEGIN?

KEEP MOVING YOUR ARM UNTIL YOU GET THE HANG OF IT!

OR... TRACE A PLATE!

START WITH A CIRCLE.

NEXT, ADD A CROPPED V AT THE BASE OF THE CIRCLE.

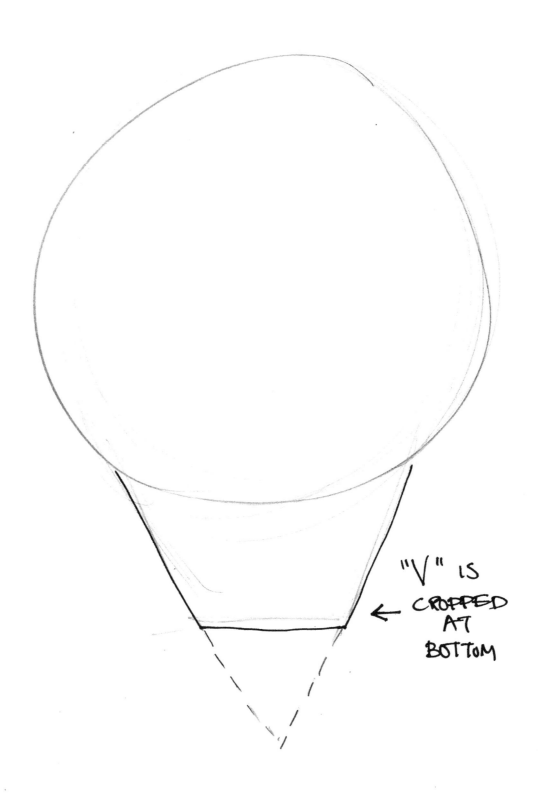

"V" IS CROPPED AT BOTTOM

NEXT, ADD YOUR GUIDELINES!

FIRST, ADD A LINE STRAIGHT DOWN THE CENTER OF THE CIRCLE →

SECOND, ADD ANOTHER LINE — HALFWAY BETWEEN THE VERTICAL CENTERLINE AND THE CIRCLE'S EDGE

THIRD, ADD A LINE ACROSS THE MIDDLE OF THE CIRCLE

VERTICAL CENTERLINE

CIRCLE'S EDGE

AND A LINE TO REMIND YOU WHERE THAT CIRCLE BASE IS LOCATED

AND A LOOSE CIRCLE, AROUND THE INTER-SECTION OF THESE POINTS

NOW WE ARE READY TO START PLACING OUR FEATURES.
CAN YOU SEE HIM START TO EMERGE?

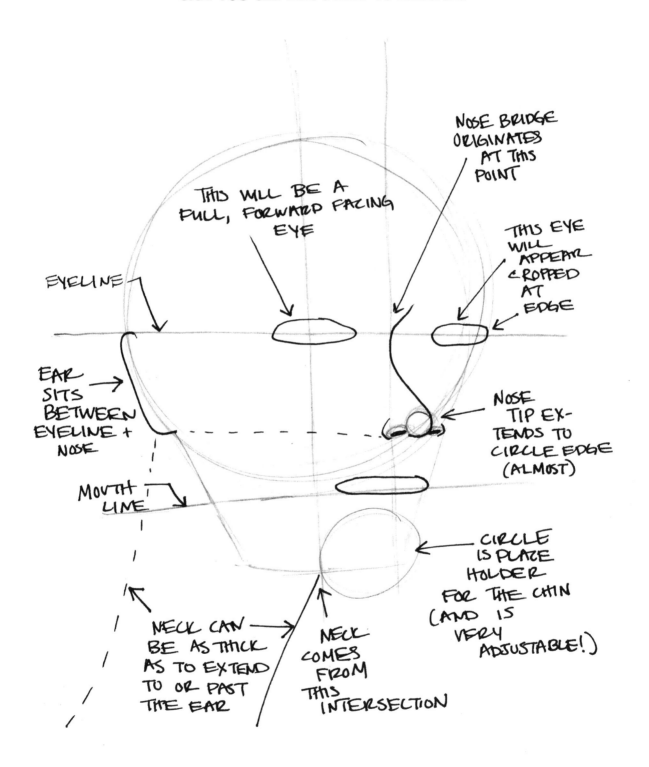

NOSE BRIDGE ORIGINATES AT THIS POINT

THIS WILL BE A FULL, FORWARD FACING EYE

THIS EYE WILL APPEAR CROPPED AT EDGE

EYELINE

EAR SITS BETWEEN EYELINE + NOSE

NOSE TIP EXTENDS TO CIRCLE EDGE (ALMOST)

MOUTH LINE

CIRCLE IS PLACE HOLDER FOR THE CHIN (AND IS VERY ADJUSTABLE!)

NECK CAN BE AS THICK AS TO EXTEND TO OR PAST THE EAR

NECK COMES FROM THIS INTERSECTION

NOW LET'S PUT IT ALL TOGETHER. I'LL LEAVE THE GUIDELINES IN PLACE SO YOU CAN SEE HOW EVERYTHING RELATES. I'LL ALSO HIGHLIGHT SOME OPTIONAL MAN FACIAL FEATURES THAT ARE FUN TO INCLUDE!

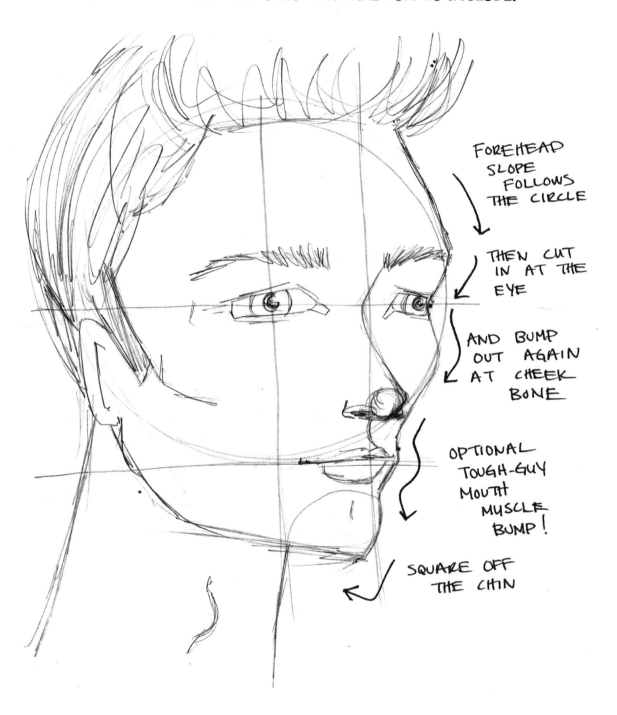

FOREHEAD SLOPE FOLLOWS THE CIRCLE

THEN CUT IN AT THE EYE

AND BUMP OUT AGAIN AT CHEEK BONE

OPTIONAL TOUGH-GUY MOUTH MUSCLE BUMP!

SQUARE OFF THE CHIN

NOW YOU CAN ERASE THOSE GUIDELINES.

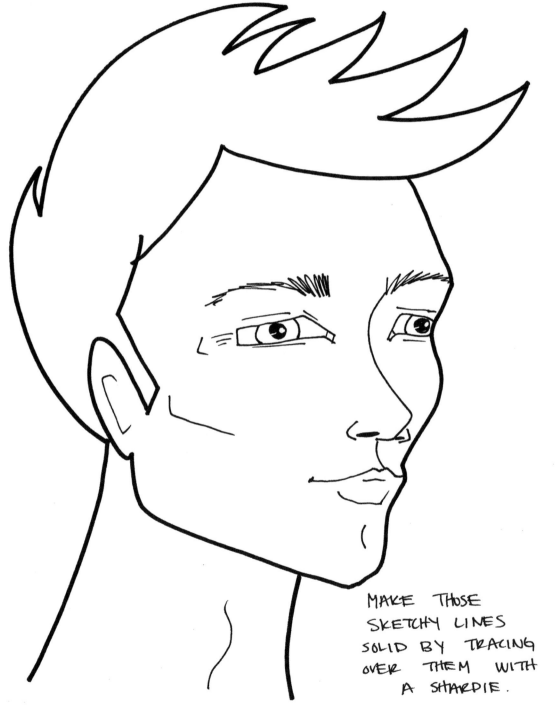

MAKE THOSE
SKETCHY LINES
SOLID BY TRACING
OVER THEM WITH
A SHARPIE.

WELL HELLOOOO HANDSOME!

LET'S TAKE ONE MORE CLOSER LOOK AT THE 3/4 PORTRAIT FEATURES
TO MAKE SURE WE KNOW EXACTLY WHAT IS GOING ON WITH THEM.

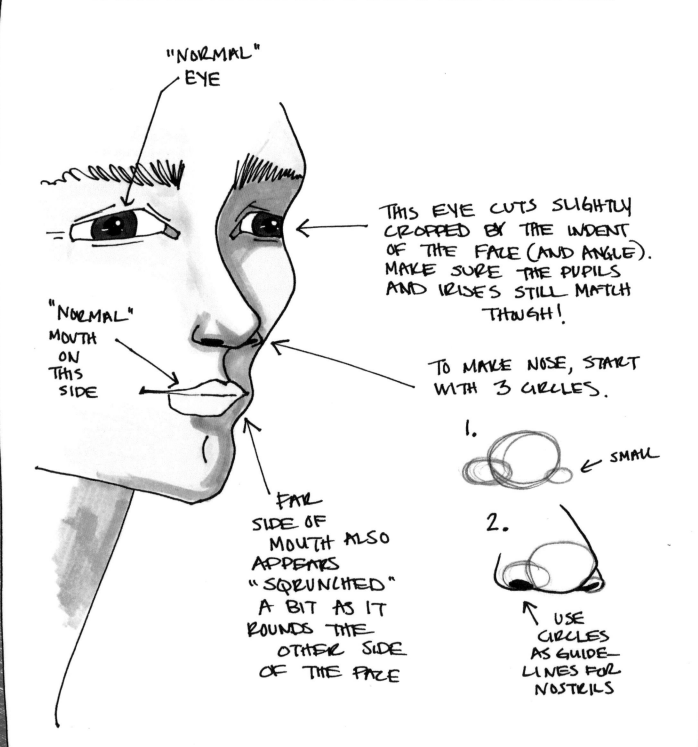

"NORMAL"
EYE

THIS EYE CUTS SLIGHTLY
CROPPED BY THE INDENT
OF THE FACE (AND ANGLE).
MAKE SURE THE PUPILS
AND IRISES STILL MATCH
THOUGH!

"NORMAL"
MOUTH
ON
THIS
SIDE

TO MAKE NOSE, START
WITH 3 CIRCLES.

1.
← SMALL

2.

↖ USE
CIRCLES
AS GUIDE-
LINES FOR
NOSTRILS

FAR
SIDE OF
MOUTH ALSO
APPEARS
"SQRUNCHED"
A BIT AS IT
ROUNDS THE
OTHER SIDE
OF THE FACE

LET'S RECAP THE 3/4 PORTRAIT. START WITH THE GRID LINES, MAKE THEM
WORK FOR YOU. AND OF COURSE, PRACTICING MAKES ALL THE DIFFERENCE!

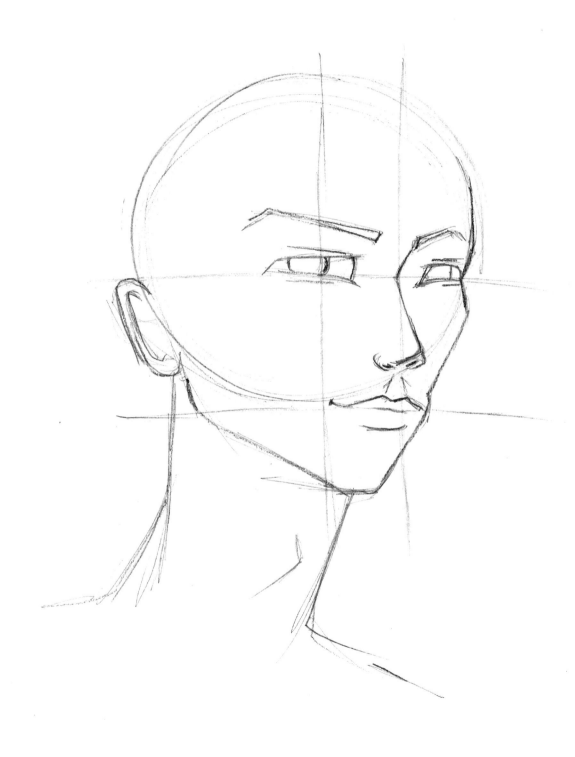

NEXT, DEFINE YOUR FINAL LINES WITH DARKER PENCIL OR PEN AND ERASE THOSE GUIDELINES.

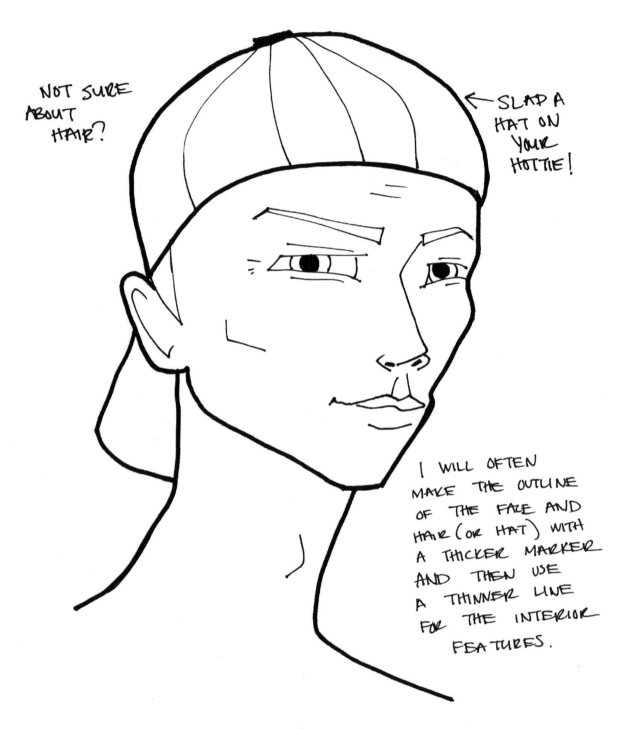

NOT SURE ABOUT HAIR?

← SLAP A HAT ON YOUR HOTTIE!

I WILL OFTEN MAKE THE OUTLINE OF THE FACE AND HAIR (OR HAT) WITH A THICKER MARKER AND THEN USE A THINNER LINE FOR THE INTERIOR FEATURES.

DECIDE ON WHAT OR WHO YOUR CHARACTER WILL BECOME!

SHADING 3/4 PORTRAITS IS EXACTLY LIKE SHADING A FRONT FACE.
YOU START WITH YOUR 3 SHADES OF SKIN TONE AND THEN FIGURE OUT
WHERE YOUR LIGHT IS SHINING. ALL PARTS CLOSEST TO THE LIGHT ARE THE
LIGHTEST COLOR, AND ALL THE NOOKS, CRANNIES AND PLANES AWAY FROM
IT ARE DARK.

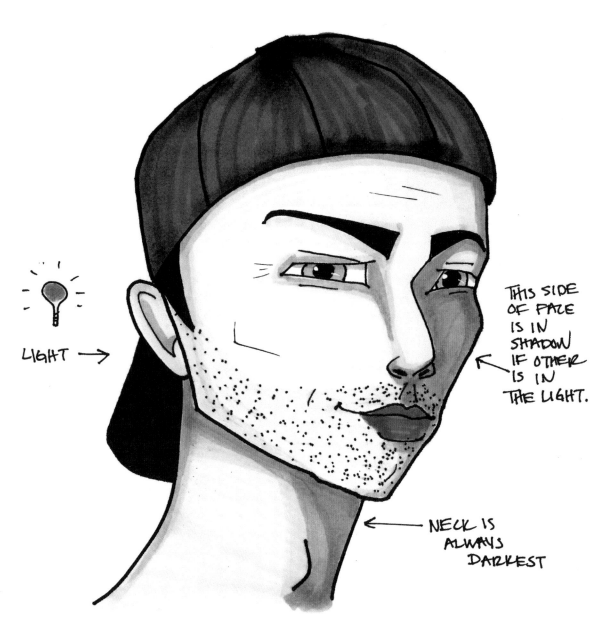

LIGHT →

THIS SIDE
OF FACE
IS IN
SHADOW
IF OTHER
IS IN
THE LIGHT.

NECK IS
ALWAYS
DARKEST

DO ONE PASS AT A TIME AND END WITH YOUR HIGHLIGHTS AND DONE!

3/4 SHADING GUIDE

HERE'S A HELPFUL CHART FOR SHADING ALL YOUR HANDSOME 3/4 FELLAS!

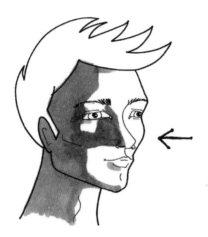

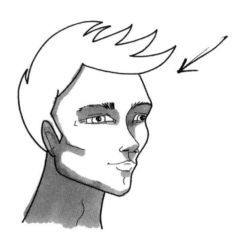

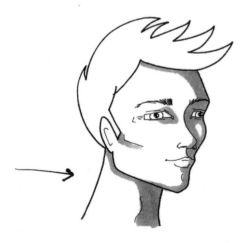

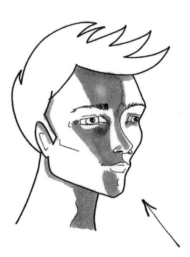

THE PROFILE

LAST BUT NOT LEAST, LET'S LEARN HOW TO DRAW OUR FUN, FAB, FELLAS FROM THE SIDE. FIRST THINGS FIRST, OUR TRUSTY CIRCLE AND 2 LINES.

LINE DOWN THE MIDDLE

CENTERLINE

YOU KNOW THE DRILL. NO ERASING TILL WE ARE DONE WITH THESE!

LINE AT BASE OF CIRCLE

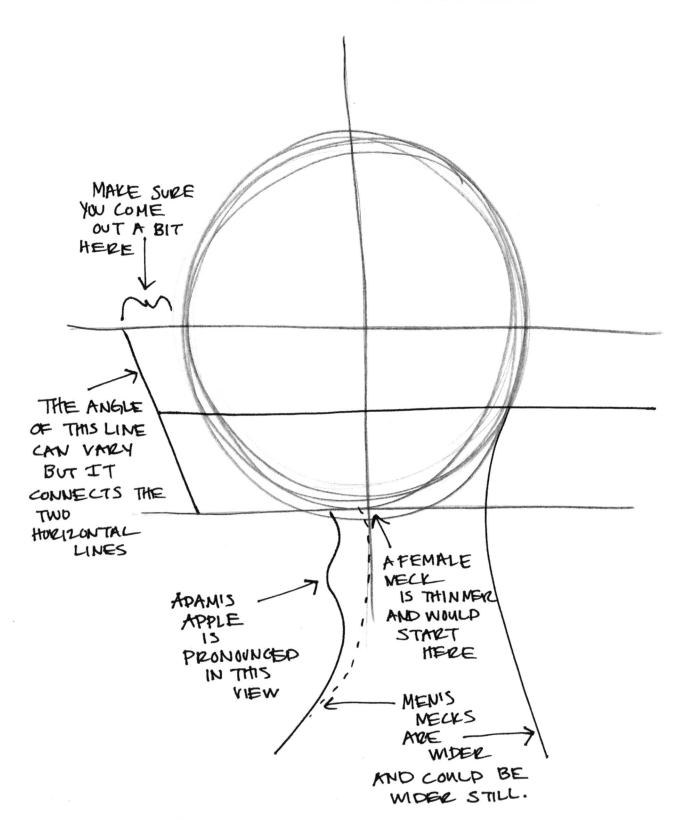

MAKE SURE YOU COME OUT A BIT HERE

THE ANGLE OF THIS LINE CAN VARY BUT IT CONNECTS THE TWO HORIZONTAL LINES

ADAM'S APPLE IS PRONOUNCED IN THIS VIEW

A FEMALE NECK IS THINNER AND WOULD START HERE

MEN'S NECKS ARE WIDER AND COULD BE WIDER STILL.

ALMOST THERE! I KNOW IT SEEMS LIKE A LOT OF STEPS BUT PLACEMENT IS EVERYTHING. AND WITH PRACTICE YOU'LL BE ABLE TO SKIP SOME. SO WHAT ARE YOU WAITING FOR? GET TO IT!

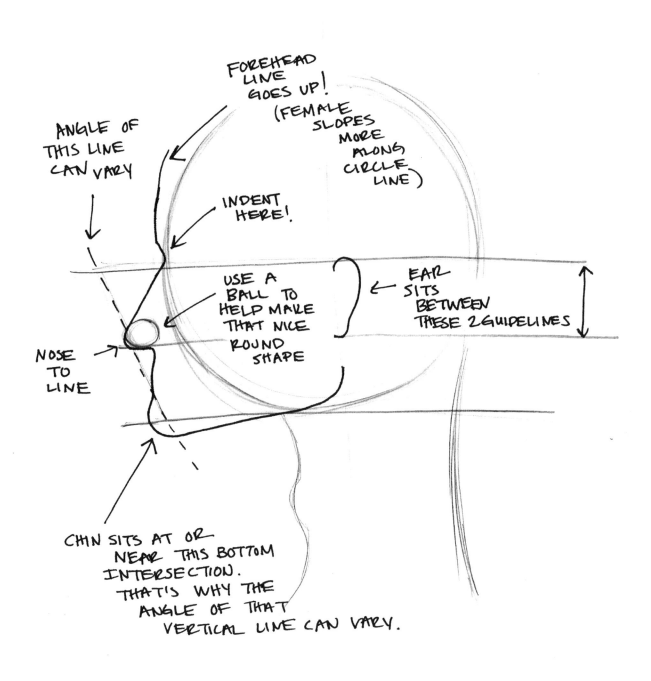

THE FACIAL FEATURES IN THE SIDE PROFILE VIEW ARE KEPT VERY SIMPLIFIED.

EYES:

OR

← NO LASHES

MINIMAL LASHES

NOSES:
SHOULD BE KEPT ANGULAR IF POSSIBLE.

LIPS:
AGAIN. SIMPLE! SMALL!

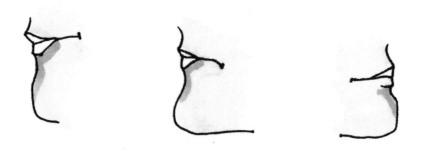

NOW LET'S GO PUT IT ALL TOGETHER.

ONCE AGAIN, LET'S START BUILDING THIS GUY FROM THE BEGINNING AND
SEE WHO WE END UP WITH!

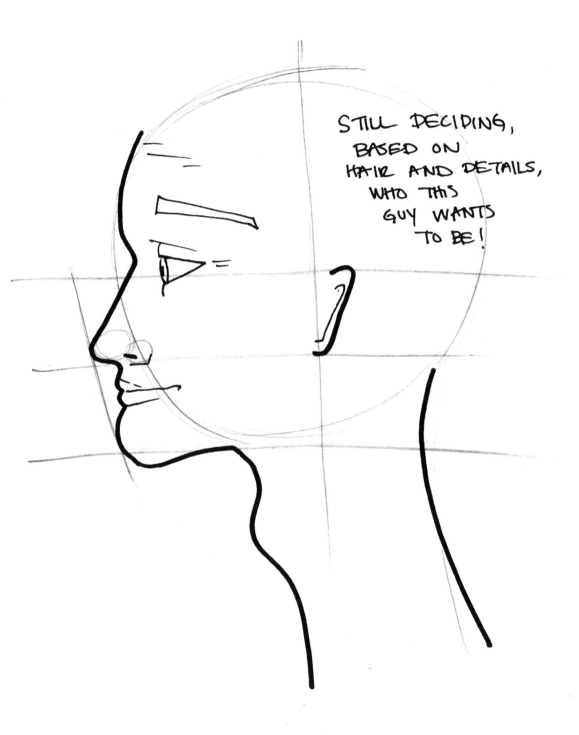

STILL DECIDING,
BASED ON
HAIR AND DETAILS,
WHO THIS
GUY WANTS
TO BE!

THIS STAGE OF PORTRAIT BUILDING IS MY FAVORITE.
FINE TUNING MY CHARACTER, ADDING HAIR AND ERASING THOSE
(PESKY) GUIDELINES ONCE I KNOW I GOT IT ALL DOWN CORRECTLY!

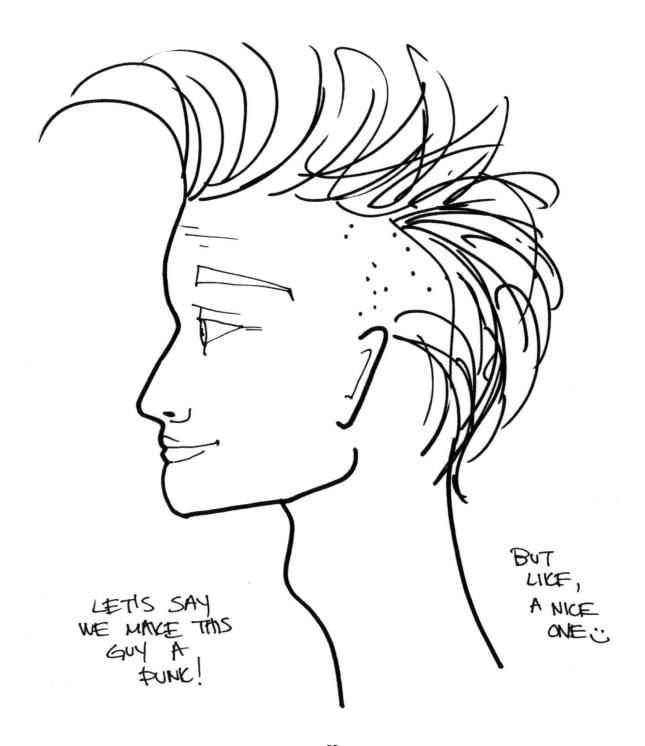

LET'S SAY
WE MAKE THIS
GUY A
PUNK!

BUT
LIKE,
A NICE
ONE :)

AND THEN HAVE A BLAST COLORING THAT BAD BOY IN!

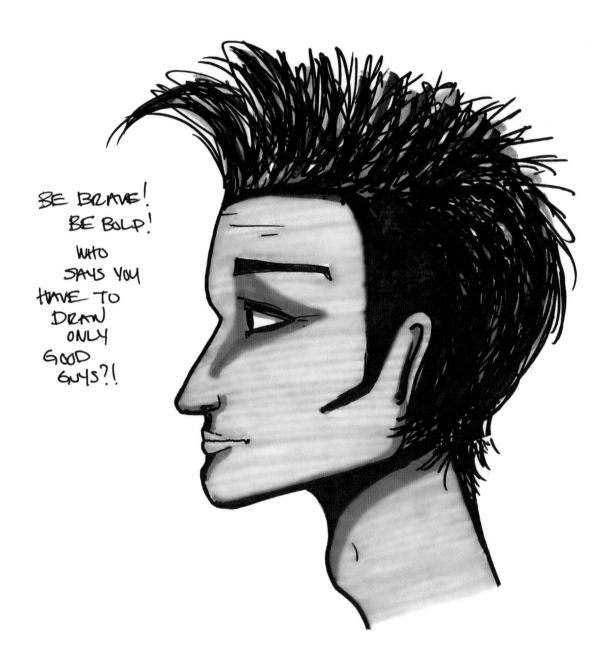

BE BRAVE!
BE BOLD!
WHO SAYS YOU HAVE TO DRAW ONLY GOOD GUYS?!

PROFILE SHADING GUIDE

HERE IS ANOTHER SHADING GUIDE TO GIVE YOU IDEAS FOR ADDING DEPTH, DRAMA AND ATTITUDE TO YOUR GUYS.

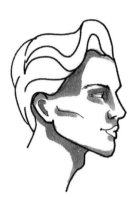

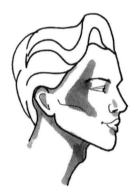

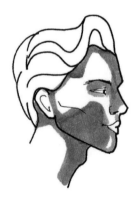

STILL NEED IDEAS? USE A PHOTO REFERENCE!

NOW THAT YOU HAVE GONE THROUGH EACH ANGLE OF THE MALE FACE YOU WILL BE SET UP FOR A LIFETIME OF DRAWING FUN! AS YOU FIND YOURSELF ADVANCING AND HONING YOUR SKILLS THROUGH PRACTICE, YOU MAY FIND THAT THE PLACEMENT OF THE HEAD AND FEATURES BECOME MORE INNATE AND YOU'LL NEED FEWER GUIDELINES TO GET YOU WHERE YOU NEED TO GO. THAT BEING SAID, USING GUIDELINES FOR ANY DRAWING IS ALWAYS A GOOD TRICK TO FALL BACK ON WHETHER YOU'RE DRAWING A FACE, A LAMP, OR A TIGER, SO DON'T EVER HESITATE TO USE THEM EACH AND EVERY TIME IF YOU NEED TO.

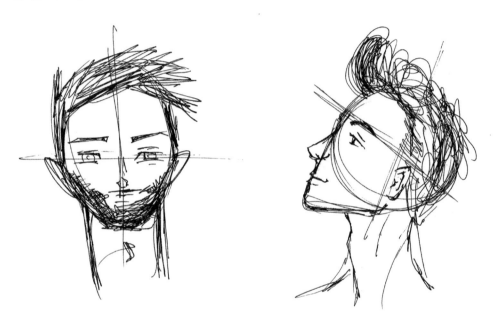

I HOPE YOU HAD A BLAST LEARNING HOW TO DRAW THESE FUN, FAB FELLAS WITH ME! IF YOU'RE LOOKING FOR FURTHER, REAL-TIME VIDEO INSTRUCTION ON THIS VERY SAME TOPIC (AS WELL AS MANY OTHERS), BE SURE TO CHECK OUT MY CLASSES AT AWESOMEARTSCHOOL.COM. THERE'S A FELLAS CLASS IN THERE MADE JUST FOR YOU! AND NO MATTER WHAT YOU'RE DRAWING MAKE SURE TO PRACTICE AND ALWAYS HAVE FUN!!!

CHECK OUT MORE BOOKS BY
KAREN CAMPBELL

ABOUT THE AUTHOR

KAREN CAMPBELL

KAREN IS A FULL TIME ARTIST. SHE LIVES IN APEX, NC WITH HER SUPER SUPPORTIVE HUSBAND AND THREE TOTALLY AWESOME BOYS.

To learn all about Karen and her ongoing artful adventures, please visit www.karencampbellartist.com

See videos of the artist at work! youtube.com/karencampbellartist

Printed in Great Britain
by Amazon